daughter
MOTHER sister
friend SERVANT
LEADER GIVER
healer

PINK Impact
A GATEWAY WOMEN'S CONFERENCE

GATEWAY
CREATE
PUBLISHING

For this reason I bow my knees to the Father of our Lord Jesus Christ, from whom the whole family in heaven and earth is named, that He would give you, according to the riches of His glory, power to be strengthened by His Spirit in the inner man, and that Christ may dwell in your hearts through faith; that you, being rooted and grounded in love, may be able to comprehend with all saints what is the breadth and length and depth and height, and to know the love of Christ which surpasses knowledge; that you may be filled with all the fullness of God.

Now to Him who is able to do exceedingly abundantly beyond all that we ask or imagine, according to the power that works in us, to Him be the glory in the church and in Christ Jesus throughout all generations, forever and ever. Amen.

—EPHESIANS 3:14–21, MEV

You Can Trust God's Promises

God knows you, and He knows what you need. He has provided promises in His Word that give assurance and direction for every situation you face. These promises from God's Word, combined with the beautiful artwork in this coloring book, will provide peace and hope as you let go of fear, worry, and anxiety and trust that God's promises are true.

Don't miss the short quotations placed on the facing page of each design. Each one was chosen to complement the illustration while reminding you of the precious promises God makes to us in His Word. As you color each design, you might want to reflect quietly on each verse or even say a prayer. Like many people, you may find that the cares and worries of life melt away as you focus your thoughts on God's many promises to protect, heal, save, and keep you.

Think back to times in your past when God has kept His promises and brought you through a hopeless situation or tough problem. Record these memories in this book or a journal. Remembering God's faithfulness will build your faith that He is able to meet every need that you face now or in your future. You can trust Him. And when you do, His peace, "which surpasses all understanding, will protect your hearts and minds through Christ Jesus" (Phil. 4:7).

It might interest you to know that the quotations in this book are taken from the Modern English Version of the Holy Bible. The Modern English Version (MEV) is the most modern translation produced in the King James tradition within the last thirty years. This formal equivalence translation maintains the beauty of the past yet provides fresh clarity for a new generation of Bible readers. If you would like more information on the MEV, please visit www.mevbible.com.

We hope you find this coloring book to be both beautiful and inspirational. And as you color, remember that the best artistic endeavors have no rules. Unleash your creativity as you experiment with colors, textures, and mediums. Freedom of self-expression will help to release wellness, balance, mindfulness, and inner peace into your life, allowing you to enjoy the process as well as the finished product. When you're finished, you can frame your favorite creations for displaying or gift giving.

For I know the plans that I have for you, says the Lord,

plans for peace and not for evil, to give you a future and a hope.

—Jeremiah 29:11, MEV

For I am persuaded that neither death nor life, neither angels nor principalities nor powers, neither things present nor things to come, neither height nor depth, nor any other created thing, shall be able to separate us from the love of God, which is in Christ Jesus our Lord.

—ROMANS 8:38–39, MEV

I can do all things because of Christ who strengthens me.

—PHILIPPIANS *4:13*, MEV

So now abide faith, hope, and love, these three.

But the greatest of these is love.

—1 Corinthians 13:13, mev

You shall know the truth, and the truth shall set you free.

—John 8:32, MEV

Do not let mercy and truth forsake you; bind them around your neck, write them on the tablet of your heart, so you will find favor and good understanding in the sight of God and man.

—*Proverbs 3:3–4, MEV*

But seek first the kingdom of God and His righteousness, and

all these things shall be given to you.

—Matthew 6:33, MEV

There is therefore now no condemnation for those who are in Christ Jesus, who walk not according to the flesh, but according to the Spirit.

—ROMANS 8:1, MEV

Come to Me, all you who labor and are heavily burdened,

and I will give you rest. Take My yoke upon you, and learn

from Me. For I am meek and lowly in heart,

and you will find rest for your souls.

—MATTHEW 11:28–29, MEV

Write your favorite promise verse inside the heart on the next page.

Let us then come with confidence to the throne of grace,

that we may obtain mercy and find grace to help in time of need.

—HEBREWS 4:16, MEV

I have loved you with an everlasting love.

—*JEREMIAH 31:3,* MEV

But my God shall supply your every need according

to His riches in glory by Christ Jesus.

—PHILIPPIANS *4:19*, MEV

Be anxious for nothing, but in everything, by prayer and supplication

with gratitude, make your requests known to God.

—PHILIPPIANS 4:6, MEV

Now He who supplies seed to the sower and supplies bread for your food will also multiply your seed sown and increase the fruits of your righteousness.

—2 CORINTHIANS 9:10, MEV

Remember, I am with you, and I will protect you

wherever you go, and I will bring you back to

this land. For I will not leave you until

I have done what I promised you.

—GENESIS 28:15, MEV

Now may the God of hope fill you with all joy and

peace in believing, so that you may abound in

hope, through the power of the Holy Spirit.

—Romans 15:13, MEV

Love suffers long and is kind; love envies not; love flaunts not itself and is not puffed up, does not behave itself improperly, seeks not its own, is not easily provoked, thinks no evil; rejoices not in iniquity, but rejoices in the truth; bears all things, believes all things, hopes all things, and endures all things.

—1 CORINTHIANS 13:4–7, MEV

She opens her mouth with wisdom,

and in her tongue is the teaching of kindness.

—Proverbs 31:26, MEV

For the LORD your God is bringing you into a good land, a land of brooks of water, of fountains and springs that flow out of valleys and hills.

—*DEUTERONOMY 8:7, MEV*

Now to Him who is able to do exceedingly abundantly

beyond all that we ask or imagine, according to

the power that works in us, to Him be the glory

in the church and in Christ Jesus throughout all

generations, forever and ever. Amen.

—EPHESIANS 3:20–21, MEV

We know that all things work together for good to those who love God, to those who are called according to His purpose.

—Romans 8:28, MEV

Pleasant words are as a honeycomb,

sweet to the soul and health to the bones.

—*Proverbs 16:24*, MEV

The heavens declare the glory of God, and

the firmament shows His handiwork.

—Psalm 19:1, MEV

Charm is deceitful, and beauty is vain,

but a woman who fears the Lord, she shall be praised.

—*Proverbs 31:30,* MEV

Therefore, whether you eat, or drink, or whatever

you do, do it all to the glory of God.

—1 Corinthians 10:31, MEV

Therefore, whether you eat, or drink...

...do it all to the glory of God.

1 Corinthians 10:31

For He satisfies the longing soul and fills

the hungry soul with goodness.

—Psalm 107:9, MEV

To everything there is a season,

a time for every purpose under heaven.

—*Ecclesiastes 3:1,* MEV

Look, children are a gift of the L~ORD~*, and*

the fruit of the womb is a reward.

—P~SALM~ 127:3, ~MEV~

Are not two sparrows sold for a penny? And not one of them will fall to the ground without your Father. But the very hairs of your head are all numbered. Therefore do not fear. You are more valuable than many sparrows.

—MATTHEW 10:29–31, MEV

When a woman is giving birth, she has pain, because

her hour has come. But as soon as she delivers the child,

she no longer remembers the anguish for joy that

a child is born into the world.

—*John 16:21,* MEV

I am with you always, even to the end of the age.

—*Matthew 28:20, MEV*

God is my strong fortress,

and He sets the blameless on His way.

—2 SAMUEL 22:33, MEV

A father of the fatherless, and a protector of the widows,

is God in His holy habitation.

—Psalm 68:5, MEV

Peace I leave with you. My peace I give to you. Not as the world gives do I give to you. Let not your heart be troubled, neither let it be afraid.

—JOHN 14:27, MEV

Have not I commanded you? Be strong and courageous. Do not be afraid or dismayed, for the LORD your God is with you wherever you go.

—JOSHUA 1:9, MEV

You will make known to me the path of life; in Your

presence is fullness of joy; at Your right hand

there are pleasures for evermore.

—Psalm 16:11, mev

For this reason we do not lose heart: Even though our outward man is perishing, yet our inward man is being renewed day by day. Our light affliction, which lasts but for a moment, works for us a far more exceeding and eternal weight of glory, while we do not look at the things which are seen, but at the things which are not seen. For the things which are seen are temporal, but the things which are not seen are eternal.

—2 CORINTHIANS 4:16–18, MEV

The LORD your God is in your midst, a Mighty One,

who will save. He will rejoice over you with

gladness, He will renew you with His love,

He will rejoice over you with singing.

—ZEPHANIAH 3:17, MEV

But He said to me, "My grace is sufficient for you, for My strength is made perfect in weakness." Therefore most gladly I will boast in my weaknesses, that the power of Christ may rest upon me.

—2 Corinthians 12:9, MEV

For the LORD gives wisdom; out of His mouth come knowledge and understanding. He lays up sound wisdom for the righteous; He is a shield to those who walk uprightly. He keeps the paths of justice, and preserves the way of His saints.

—PROVERBS 2:6–8, MEV

Cast all your care upon Him,

because He cares for you.

—1 Peter 5:7, MEV

Do not be conformed to this world, but be transformed by the renewing of your mind, that you may prove what is the good and acceptable and perfect will of God.

—ROMANS 12:2, MEV

My sheep hear My voice,

and I know them, and they follow Me.

—John 10:27, MEV

Preserve me, O God,

for in You I take refuge.

—Psalm 16:1, MEV

Jesus answered, "You say correctly that I am a king.

For this reason I was born, and for this reason I came

into the world, to bear witness to the truth. Everyone

who is of the truth hears My voice."

—JOHN 18:37B, MEV

Rejoice greatly, O daughter of Zion! And cry aloud,

O daughter of Jerusalem! See, your king is coming to

you; he is righteous and able to deliver.

—Zechariah 9:9a, MEV

GLORY TO THE NEWBORN KING

Daughter Mother Sister Friend Servant Leader Giver Healer
Published by Passio
Charisma Media/Charisma House Book Group
In collaboration with Gateway Create Publishing
600 Rinehart Road
Lake Mary, Florida 32746
www.charismahouse.com

All Scripture quotations are taken from the Holy Bible, Modern English
Version. Copyright © 2014 by Military Bible Association. Used by
permission. All rights reserved.

Design Director: Justin Evans
Cover Design: Gabi Ferrara
Interior Design: Justin Evans, Lisa Rae McClure, Vincent Pirozzi

Illustrations: Getty Images / Depositphotos

International Standard Book Number: 978-0-9974298-3-1

First edition

16 17 18 19 20 — 987654321

Printed in the United States of America